Men
To
Love, Dad & Mom M.

CHRISTOPHER DOCK
Mennonite Schoolmaster

NECESSARY RULES
for
Children
— in —
PENNSYLVANIA
Dutch Country

Edited by Paul Breon
Photography by Tonya Wilhelm

Published by The History Press
Charleston, SC 29403
www.historypress.net

Introduction and Discussion Guide Copyright © 2015 by Paul Breon
Photography Copyright © 2015 by Tonya Wilhelm
All rights reserved

"A Hundred Necessary Rules of Conduct for Children," by Christopher Dock, published as "Hundert Noethige Sitten-Regeln für Kinder" in *Geistliches* magazine, issue 40, by Christopher Saur. Germantown, Pennsylvania Colony, 1764.
English translation by Samuel W. Pennypacker, published in *Historical and Biographical Sketches* by Robert A. Tripple. Philadelphia, 1883.

First published 2015

Manufactured in the United States

ISBN 978.1.46711.831.6

Library of Congress Control Number: 2015939783

Notice: The information in this book is true and complete to the best of our knowledge. It is offered without guarantee on the part of the author or The History Press. The author and The History Press disclaim all liability in connection with the use of this book.

All rights reserved. No part of this book may be reproduced or transmitted in any form whatsoever without prior written permission from the publisher except in the case of brief quotations embodied in critical articles and reviews.

Contents

Acknowledgements..7
Introduction..9

A Hundred Necessary Rules
 of Conduct for Children.......................................11

Discussion Guide...63
After Reading Activities:
 For Teachers and Homeschooling Parents............91

Acknowledgements

The photographic illustrations in this book took place at the 1798 Joseph Priestly House and the 1834 Joseph Priestly Memorial Chapel in central Pennsylvania.

For photography at the Joseph Priestley House, we appreciate the assistance of the Friends of Joseph Priestley House and the Pennsylvania Historical and Museum Commission.

For photography at the Joseph Priestley Memorial Chapel, we appreciate the assistance of the Priestley Chapel Associates.

The photographic illustrations in this book may be purchased, suitable for framing, at www.wilhelm-photography.com.

Introduction

The story of how this book came to be in your hands is the story of two men.

Christopher Dock emigrated from Germany to the Pennsylvania colony in 1714. A man of Mennonite faith, he opened a school for children along Skippack Creek, north of Philadelphia. He lived a humble existence, sometimes farming but mostly teaching. His influence was small, limited to the children he ministered to through providing them an education. Even though not all the students could afford to pay, they were treated fairly, and Dock was noted for being one of the few early schoolmasters who held his students in high regard. Respect—mutual respect—was the order of the day.

Encouraged by friends to share his wisdom, he was reluctant for years, but in 1764, he crafted an article that detailed his standards of behavior. "A Hundred Necessary Rules of Conduct for Children," published anonymously in the German *Geistliches* magazine, is notable for being our first known original document on the subject of etiquette in the colonies.

The rules were certainly read by and to children in the time following publication, but the magazine's readership was limited to German-speaking pre-Revolutionary colonists, and the "Rules" may have at this point been lost to history.

Introduction

Over one hundred years later, Samuel Pennypacker, governor of Pennsylvania and president of its historical society, was determined to preserve his state's history. A lover of antique books and documents, he would often spend the day with a friend walking through old shops and knocking on doors, hoping a historic volume would find its way to him.

One day, his travels took him up north of Philadelphia, along the Skippack, and he came among the Mennonite farms. His own grandfather had lived there, and many of the descendants of those first settlers still resided in colonial-era homes. Pennypacker knocked on the door of an older gentleman, presenting him with his quest to locate antique writings, were there any to be found there. The man offered him a fragile document even then over one hundred years old—a copy of the fortieth issue of *Geistliches* magazine, which contained Dock's "Rules." Pennypacker, intrigued with Dock's philosophies, and intending to honor this early colonial teacher, published a short biography and a translation of the "Rules" in his 1883 *Historical and Biographical Sketches*.

And so the "Rules" were preserved for history yet again, and many read Pennypacker's book in its day. Now, over one hundred years later, his work joins many thousands of other volumes that languish unread by many, with few having the opportunity to appreciate the wisdom and history in their pages.

In republishing Dock's work, using Pennypacker's 1883 translation, we intend to once again bring the "Rules" to the attention of the public. The "Rules" are too instructive, and too charming, to miss. We have included illustrative photographs, telling the story of a young boy and his two sisters as they do their best to obey. (Rules are one thing when read and another in the midst of life.)

Christopher Dock left little of substance behind when he died in 1771. His influence on the lives he touched cannot be measured. With our republication of his work, we hope to encourage that influence to continue.

We all seek to maintain standards of behavior, but sometimes the standards seem uncertain, especially in our day. In these pages, clarity is certainly provided.

—Paul Breon

A HUNDRED NECESSARY RULES *of* Conduct *for* Children

I. Rules for the Behavior of a Child in the House of its Parents.

A. At and after getting up in the mornings.

1. Dear child, accustom yourself to awaken at the right time in the morning without being called, and as soon as you are awake get out of bed without delay.

2. On leaving the bed fix the cover in a nice, orderly way.

3. Let your first thoughts be directed to God, according to the example of David, who says, Psalms cxxxix, 18, "When I am awake I am still with Thee," and Psalms lxiii, 7, "When I am awake I speak of Thee."

4. Offer to those who first meet you, and your parents, brothers and sisters, a good-morning, not from habit simply, but from true love.

5. Learn to dress yourself quickly but neatly.

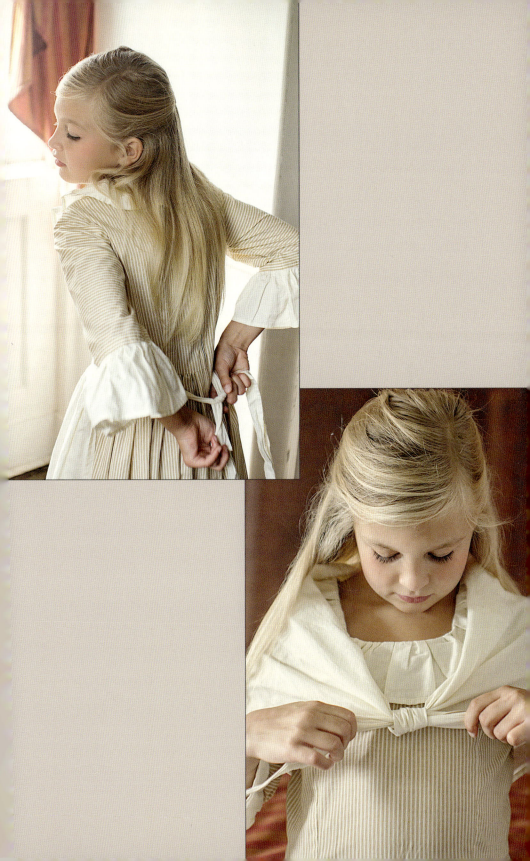

6. Instead of idle talk with your brothers and sisters or others, seek also, while dressing, to have good thoughts. Remember the clothing of righteousness which was earned for you through Jesus, and form the resolution not to soil it on this day by intentional sin.

7. When you wash your face and hands do not scatter the water about in the room.

8. To wash out the mouth every morning with water, and to rub off the teeth with the finger, tends to preserve the teeth.

9. When you comb your hair do not go out into the middle of the room, but to one side in a corner.

10. Offer up the morning prayer, not coldly from custom, but from a heart-felt thankfulness to God, Who has protected you during the night, and call upon Him feelingly to bless your doings through the day. Forget not the singing and the reading in the Bible.

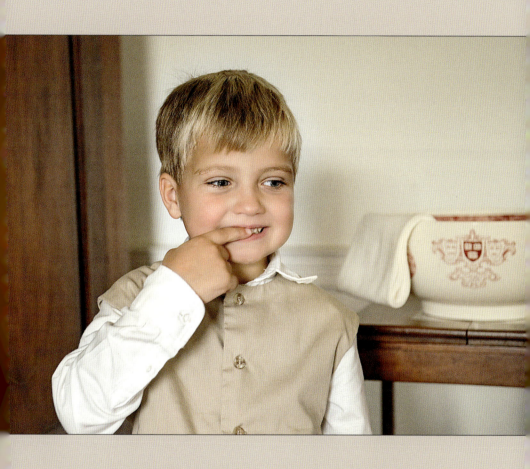

11. Do not eat your morning bread upon the road or in school, but ask your parents to give it to you at home.

12. Then get your books together and come to school at the right time.

B. *In the evenings at bed-time.*

13. After the evening meal do not sit down in a corner to sleep, but perform your evening devotions with singing, prayer and reading, before going to bed.

14. Undress yourself in a private place, or if you must do it in the presence of others, be retiring and modest.

15. Look over your clothes to see whether they are torn, so that they may be mended in time.

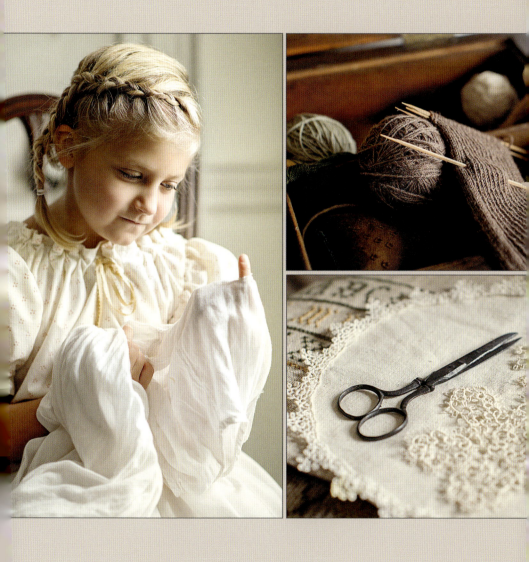

16. Do not throw your clothes about in the room, but lay them together in a certain place, so that in the morning early you can easily find them again.

17. Lie down straight in the bed modestly, and cover yourself up well.

18. Before going to sleep consider how you have spent the day, thank God for His blessings, pray to Him for the forgiveness of your sins, and commend yourself to His merciful protection.

19. Should you wake in the night, think of God and His omnipresence, and entertain no idle thoughts.

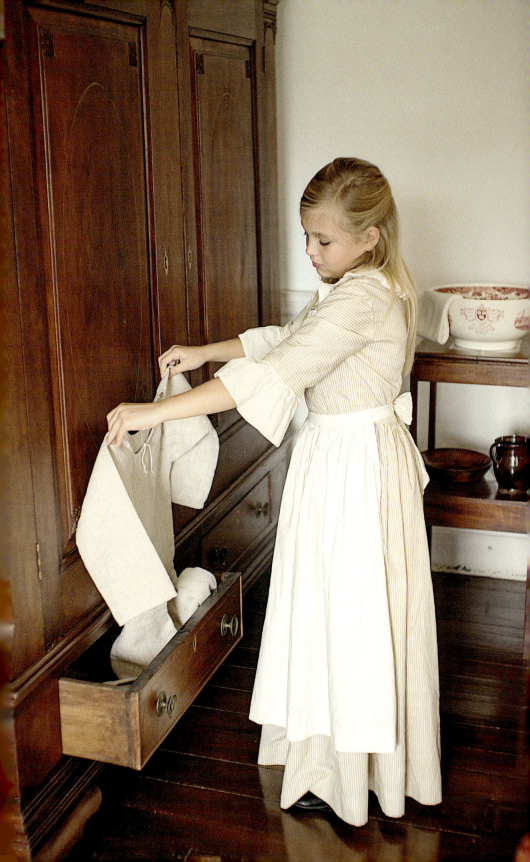

C. At meal-time.

20. Before going to the table where there are strangers, Comb and wash yourself very carefully.

21. During the grace do not let your hands hang toward the earth, or keep moving them about, but let them, with your eyes, be directed to God.

22. During the prayer do not lean or stare about, but be devout and reverent before the majesty of God.

23. After the prayer, wait until the others who are older have taken their places, and then sit down at the table quietly and modestly.

24. At the table sit very straight and still, do not wabble with your stool, and do not lay your arms on the table. Put your knife and fork upon the right and your bread on the left side.

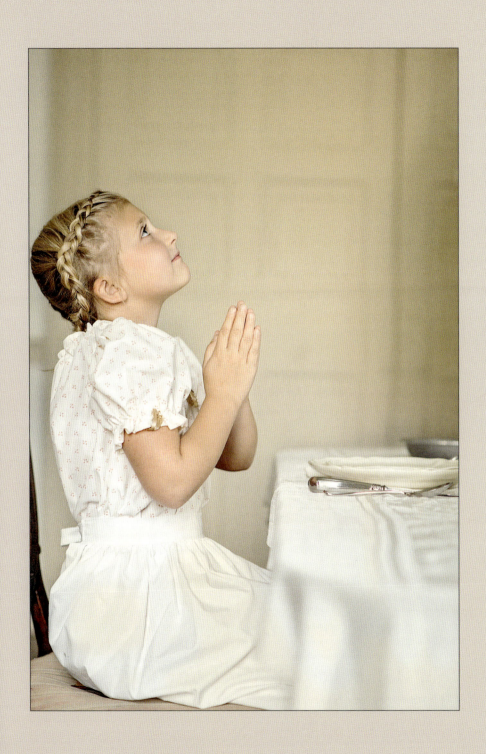

25. Avoid everything which has the appearance of eager and ravenous hunger, such as to look at the victuals anxiously, to be the first in the dish, to tear off the bread all at once in noisy bites, to eat quickly and eagerly, to take another piece of bread before the last is swallowed down, to take too large bites, to take the spoon too full, to stuff the mouth too full, & etc.

26. Stay at your place in the dish, be satisfied with what is given to you, and do not seek to have of everything.

27. Do not look upon another's plate to see whether he has received something more than you, but eat what you have with thankfulness.

28. Do not eat more meat and butter than bread, do not bite the bread off with the teeth, cut regular pieces with the knife, but do not cut them off before the mouth.

29. Take hold of your knife and spoon in an orderly way and be careful that you do not soil your clothes or the table cloth.

30. Do not lick off your greasy fingers, wipe them on a cloth, but as much as possible use a fork instead of your fingers.

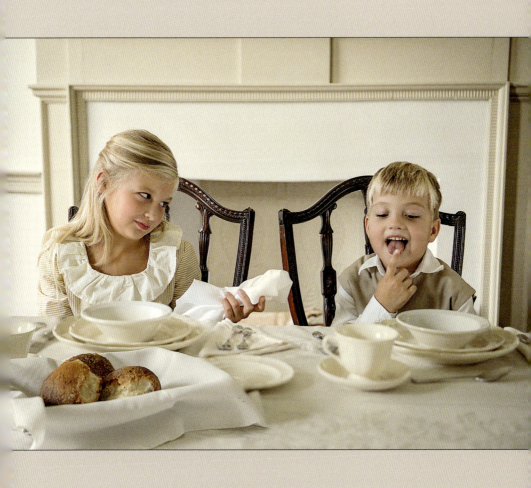

31. Chew your food with closed lips and make no noise by scraping on the plate.

32. Do not wipe the plate off either with the finger or the tongue, and do not thrust your tongue about out of your mouth. Do not lean your elbows on the table when you carry the spoon to the mouth.

33. Do not take salt out of the salt-box with your fingers, but with the point of your knife.

34. The bones, or what remains over, do not throw under the table, do not put them on the table cloth, but let them lie on the edge of the plate.

35. Picking the teeth with the knife or fork does not look well and is injurious to the gums.

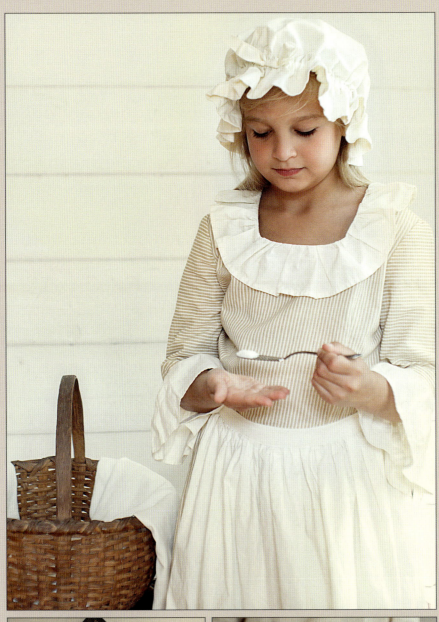

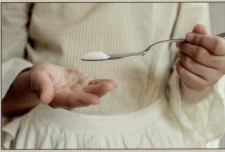

36. As much as possible abstain from blowing your nose at the table, but if necessity compels, turn your face away or hold your hand or napkin before it; also when you sneeze or cough.

37. Learn not to be delicate and over-nice or to imagine that you cannot eat this or that thing. Many must learn to eat among strangers what they could not at home.

38. To look or smell at the dish holding the provisions too closely is not well. Should you find a hair or something of the kind in the food, put it quietly and unnoticed to one side so that others be not moved to disgust.

39. As often as you receive anything on your plate, give thanks with an inclination of the head.

40. Do not gnaw the bones off with your teeth or make a noise in breaking out the marrow.

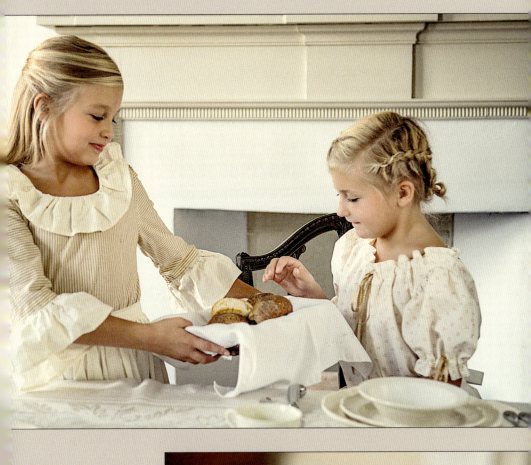

41. It is not well to put back on the dish what you have once had on your plate.

42. If you want something across the table be careful not to let your sleeve hang in the dish or to throw a glass over.

43. At table do not speak before you are asked, but if you have noticed anything good at church or school, or a suitable thought occurs to you relating to the subject of discourse, you may properly bring it forward, but listen attentively to the good things said by others.

44. When you drink you must have no food in your mouth, and must incline forward courteously.

45. It has a very bad look to take such strong draughts while drinking that one has to blow or breathe heavily; while drinking to let the eyes wander around upon others; to commence drinking at table before parents or more important persons have drunk; to raise the glass to the mouth at the same time with one of more importance; to drink while others are speaking to us; and to raise the glass many times after one another.

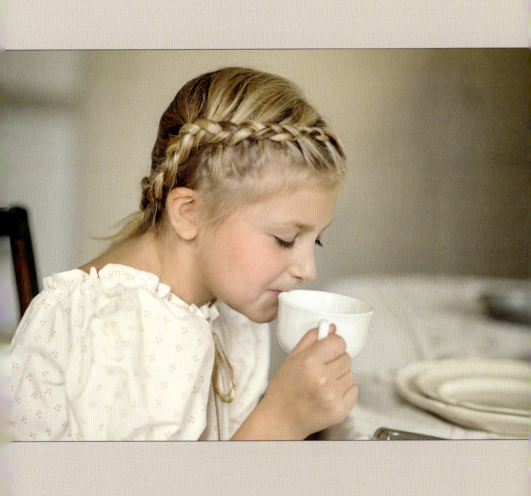

46. Before and after drinking, the mouth ought to be wiped off, not with the hand, but with a handkerchief or napkin.

47. At the table be ready to help others if there is something to be brought into the room or other thing to be done that you can do.

48. When you have had enough, get up quietly, take your stool with you, wish a pleasant mealtime, and go to one side and wait what will be commanded you. Still should one in this respect follow what is customary.

49. Do not stick the remaining bread in your pocket but let it lie on the table.

50. After leaving the table, before you do anything else, give thanks to your Creator who has fed and satisfied you.

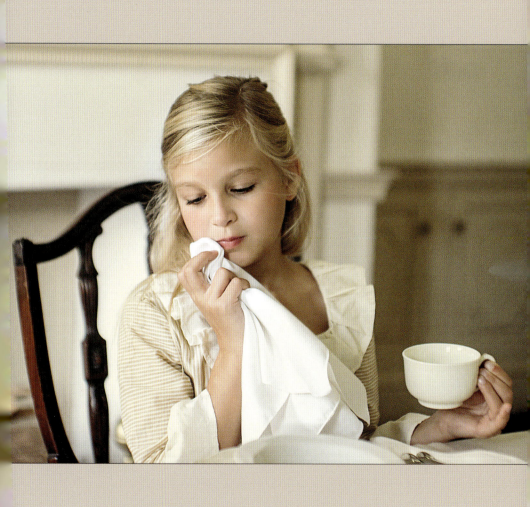

II. Rules for the Behavior of a Child in School.

51. Dear child, when you come into school, incline reverently, sit down quietly in your place, and think of the presence of God.

52. During prayers think that you are speaking with God, and when the word of God is being read, think that God is speaking with you. Be also devout and reverential.

53. When you pray aloud, speak slowly and deliberately; and when you sing, do not try to drown the voices of others, or to have the first word.

54. Be at all times obedient to your teacher, and do not let him remind you many times of the same thing.

55. Should you be punished for bad behavior, do not, either by words or gestures, show yourself impatient or obstinate, but receive it for your improvement.

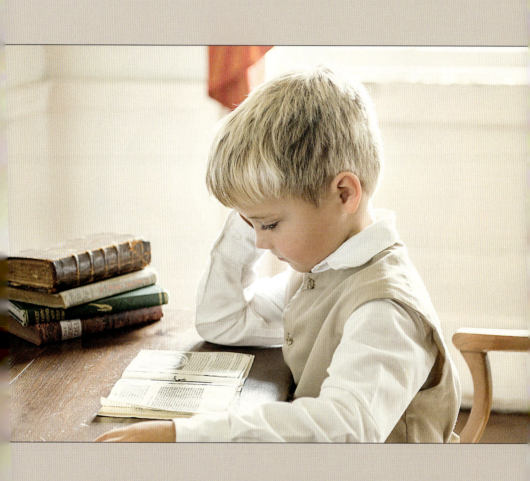

56. Abstain in school from useless talking, by which you make the work of the schoolmaster harder, vex your fellow pupils, and prevent yourself and others from paying attention.

57. Listen to all that is said to you, sit very straight and look at your teacher.

58. When you recite your lesson, turn up your book without noise, read loudly, carefully and slowly, so that every word and syllable may be understood.

59. Give more attention to yourself than to others, unless you are placed as a monitor over them.

60. If you are not questioned, be still; and do not help others when they say their lessons, but let them speak and answer for themselves.

61. To your fellow-scholars show yourself kind and peaceable, do not quarrel with them, do not kick them, do not soil their clothes with your shoes or with ink, give them no nicknames, and behave yourself in every respect toward them as you would that they should behave toward you.

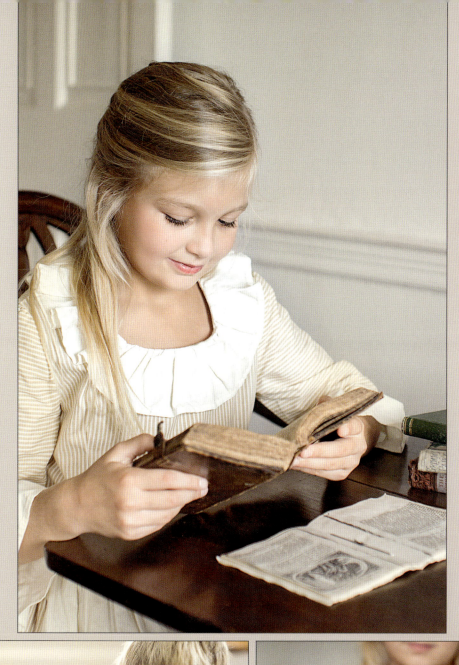
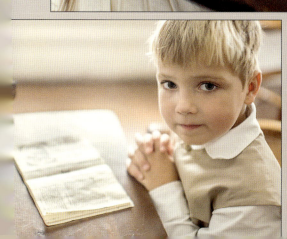

62. Abstain from all coarse, indecent habits or gestures in school, such as to stretch with the hands or the whole body from laziness; to eat fruit or other things in school; to lay your hand or arm upon your neighbor's shoulder, or under your head, or to lean your head forwards upon the table; to put your feet on the bench, or let them dangle or scrape; or to cross your legs over one another, or stretch them apart, or to spread them too wide in sitting or standing; to scratch your head; to play or pick with the fingers; to twist and turn the head forwards, backwards and sideways; to sit and sleep; to creep under the table or bench; to turn your back to your teacher; to change your clothes in school, and to show yourself restless in school.

63. Keep your books, inside and outside, very clean and neat, do not write or paint in them, do not tear them, and lose none of them.

64. When you write, do not soil your hands and face with ink, do not scatter it over the table or bench, or over your clothes or those of others.

65. When school is out, make no great noise; in going down stairs, do not jump over two or three steps at a time, by which you may be hurt, and go quietly home.

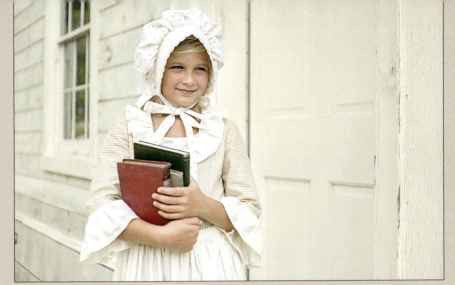
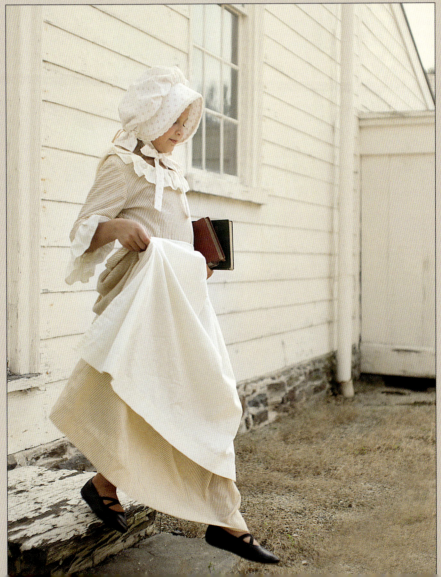

III. How a Child should Behave on the Street.

66. Dear child, although, after school, you are out of sight of your teacher, God is present in all places and you therefore have cause upon the street to be circumspect before Him and his Holy Angels.

67. Do not run wildly upon the street, do not shout, but go quietly and decently.

68. Show yourself modest, and do not openly, before other people, what ought to be done in a private place.

69. To eat upon the street is unbecoming.

70. Do not stare aloft with your eyes, do not run against people, do not tread purposely where the mud is thickest, or in the puddles.

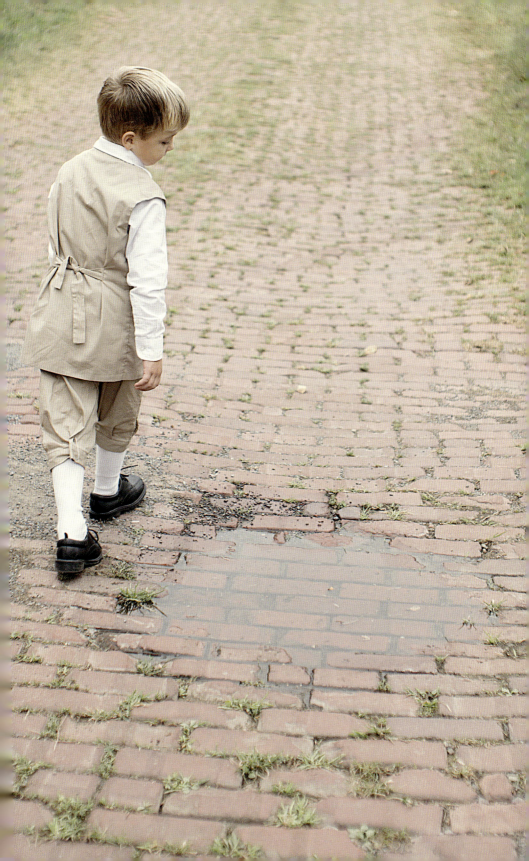

71. When you see a horse or wagon coming, step to one side, and take care that you do not get hurt, and never hang behind upon a wagon.

72. In winter do not go upon the ice or throw snowballs at others, or ride upon sleds with disorderly boys.

73. In summer do not bathe in the water or go too near it. Take no pleasure in mischievous or indecent games.

74. Do not stand in the way where people quarrel or fight, or do other evil things; associate not with evil companions who lead you astray; do not run about at the annual fair; do not stand before mountebanks or look upon the wanton dance, since there you learn nothing but evil.

75. Do not take hold of other children so as to occupy the street, or lay your arm upon the shoulders of others.

76. If any known or respectable person meets you, make way for him, bow courteously, do not wait until he is already near or opposite to you, but show to him this respect while you are still some steps from him.

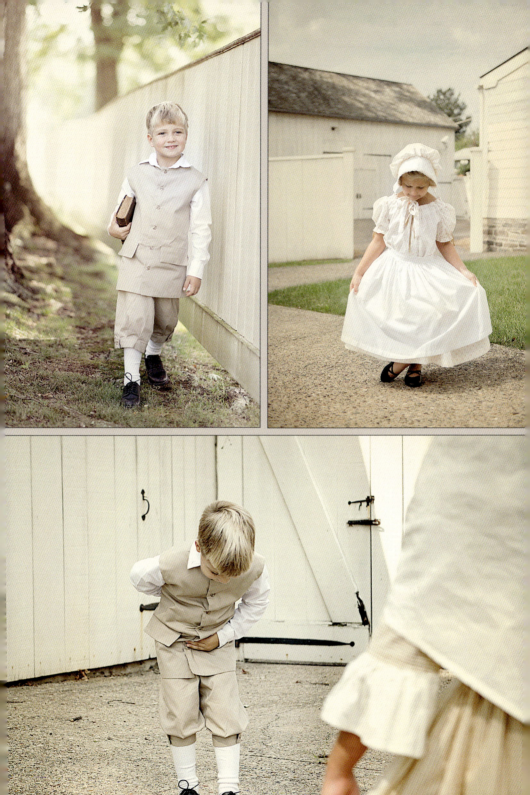

IV. Rules for the Behavior of a Child in Meeting or Church.

77. Dear child, in meeting or church think upon the holy presence of God, and that you will be judged according to the word you hear upon this day.

78. Bring your Bible and hymn book with you, and sing and pray very devoutly, since out of the mouths of young children will God be praised.

79. During the sermon be attentive to all that is said, mark what is represented by the text, and how the discourse is divided; which also you can write on your slate. Refer to other beautiful passages in your Bible, but without noise or much turning of the leaves, and mark them by laying in long narrow bits of paper, of which you must always have some lying in your Bible.

80. Do not talk in church, and if others want to talk with you do not answer. During the sermon, if you are overcome with sleep, stand up a little while and try to keep it off.

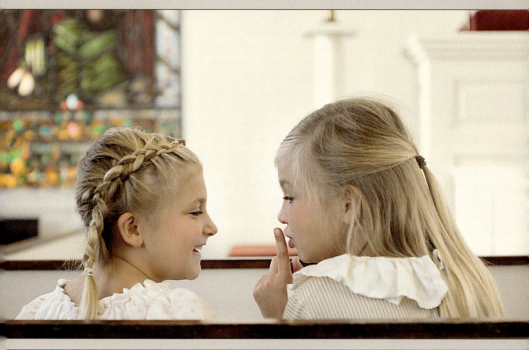
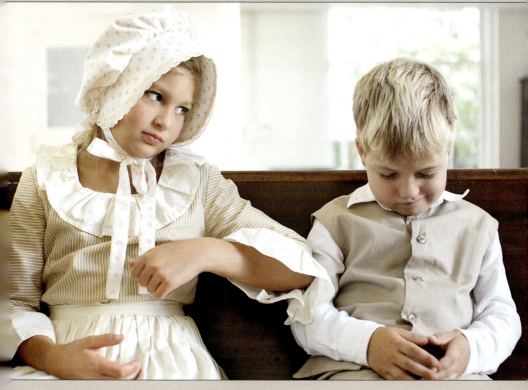

81. When the name of Jesus is mentioned or used in prayer uncover or incline your head, and show yourself devout.

82. Do not stare about the church at other people, and keep your eyes under good discipline and control.

83. All indecent habits which, under Rule No. 62, you ought to avoid in school, much more ought you to avoid in church.

84. If you, with others, should go in couples into, or out of, the church you should never, from mischief, shove, tease or bespatter, but go forth decently and quietly.

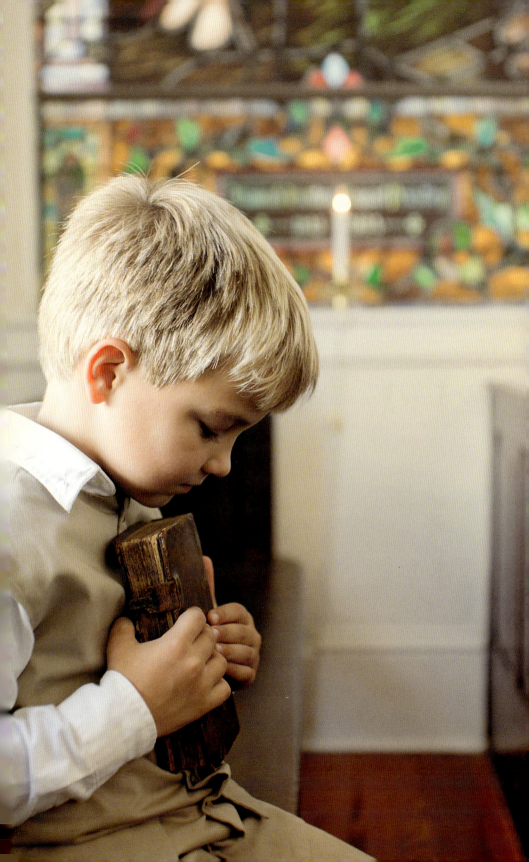

V. Rules for the Behavior of a Child under Various Circumstances.

85. Dear child, live in peace and unity with every one, and be entirely courteous from humility and true love of your neighbor.

86. Accustom yourself to be orderly in everything, lay your books and other things in a certain place and do not let them lie scattered about in a disorderly way.

87. When your parents send you on an errand, mark well the purpose for which you are sent, so that you make no mistake. When you have performed your task come quickly home again and give an answer.

88. Be never idle, but either go to assist your parents, or repeat your lessons, and learn by heart what was given you. But take care that you do not read in indecent or trifling books, or pervert the time, for which you must give an account to God, with cards or dice.

89. If you get any money, give it to some one to keep for you, so that you do not lose it, or spend it for dainties. From what you have, willingly give alms.

90. If anything is presented to you, take it with the right hand and give thanks courteously.

91. Should you happen to be where someone has left money or other things lying on the table, do not go too near or remain alone in the room.

92. Never listen at the door, Sirach 21, 24. Do not run in quickly, but knock modestly, wait until you are called, incline as you walk in, and do not slam the door.

93. Do not distort your face, in the presence of people, with frowns or sour looks; be not sulky if you are asked any thing, let the question be finished without your interrupting, and do not answer with nodding or shaking the head, but with distinct and modest words.

94. Make your reverence at all times deeply and lowly with raised face. Do not thrust your feet too far out behind. Do not turn your back to people, but your face.

95. Whether a stranger or good friend comes to the house, be courteous to him, bid him welcome, offer him a chair and wait upon him.

96. In sneezing, blowing the nose, spitting, and yawning be careful to use all possible decency. Turn your face to one side, hold the hand before it, put the uncleanliness of the nose in a handkerchief and do not look at it long, let the spittal fall upon the earth and tread upon it with your foot. Do not accustom yourself to continual hawking, grubbing at the nose, violent panting, and other disagreeable and indecent ways.

97. Never go about nasty and dirty. Cut your nails at the right time and keep your clothes, shoes and stockings, neat and clean.

98. In laughing, be moderate and modest. Do not laugh at everything, and especially at the evil or misfortune of other people.

99. If you have promised anything try to hold to it, and keep yourself from all lies and untruths.

100. Let what you see of good and decent in other Christian people serve as an example for yourself. "If there be any virtue, and if there be any praise, think on these things." Philippians iv, 8.

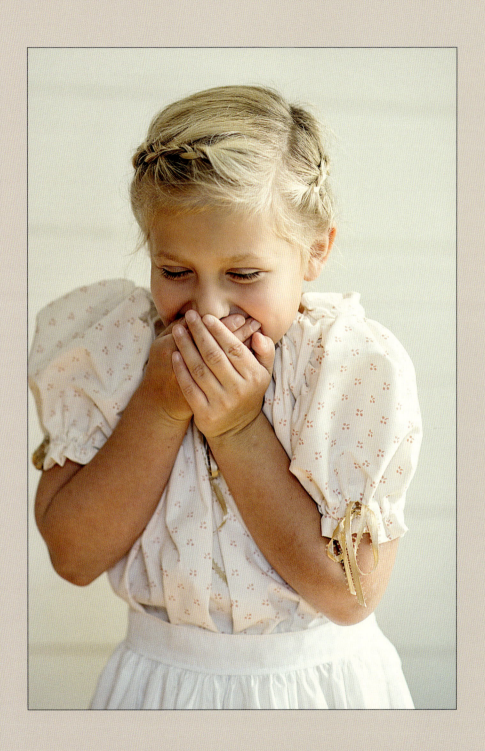

Discussion Guide

When reviewing the "Rules" with children, it is interesting to hear their modern perspectives. The following pages contain questions and comments that add background information to the "Rules" and also guide the parent or teacher in asking thoughtful questions of the child. A list of suggested activities for teachers or homeschooling parents is also included beginning on page 91.

A Hundred Necessary Rules of Conduct for Children

I. Rules for the Behavior of a Child in the House of its Parents.

A. At and after getting up in the mornings.

1. Dear child, accustom yourself to awaken at the right time in the morning without being called, and as soon as you are awake get out of bed without delay.

Discussion Guide

How would you "accustom yourself" to waking up at a certain time if you didn't have an alarm—or someone to wake you up? Do you usually "get out of bed without delay"?

2. On leaving the bed fix the cover in a nice, orderly way.

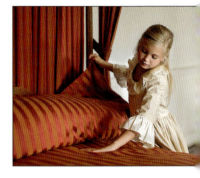

This is one rule that hasn't changed! Do your parents still need to tell you to do this?

3. Let your first thoughts be directed to God, according to the example of David, who says, Psalms cxxxix, 18, "When I am awake I am still with Thee," and Psalms lxiii, 7, "When I am awake I speak of Thee."

What is usually the first thing you think about in the morning? What do "cxxxix" and "lxiii" mean? What book are these quotations from? What do the 18 and 7 refer to? (Roman numerals were typically used for the notation of Bible chapters at this time. C represents 100, L represents 50, X represents 10 and I represents 1; and when a lower number is written before a higher number, that lower number is subtracted from the total. The 18 and 7 refer to the verses; 139 and 63 are the chapters within the book of Psalms.)

4. Offer to those who first meet you, and your parents, brothers and sisters, a good-morning, not from habit simply, but from true love.

Do you say "Good morning" to your family? If not, try it tomorrow!

5. Learn to dress yourself quickly but neatly.

What does it mean to dress "neatly"?

Discussion Guide

6. Instead of idle talk with your brothers and sisters or others, seek also, while dressing, to have good thoughts. Remember the clothing of righteousness which was earned for you through Jesus, and form the resolution not to soil it on this day by intentional sin.

> *What does it mean to "form a resolution"? (To make the decision to do something.) What does "intentional" mean? (Doing something on purpose, or deliberately.) The author of the Rules is trying to help children control their behavior by choosing carefully what they think about. Do you think the things you spend your time thinking about affect how you act? Do you think the things you watch on television, or listen to, or look at on the computer affect how you act?*

7. When you wash your face and hands do not scatter the water about in the room.

> *This is another thing that hasn't changed! Has someone ever said this to you? Or perhaps to one of your siblings?*

8. To wash out the mouth every morning with water, and to rub off the teeth with the finger, tends to preserve the teeth.

> *Why didn't the author say that children should brush their teeth?*

Discussion Guide

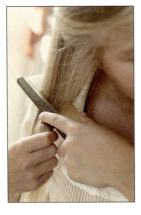

9. When you comb your hair do not go out into the middle of the room, but to one side in a corner.

Why would the author say this? Do you think this is a good rule? (Children usually bathed less in colonial days than we do today, and their hair could have an assortment of interesting items residing therein.)

10. Offer up the morning prayer, not coldly from custom, but from a heart-felt thankfulness to God, Who has protected you during the night, and call upon Him feelingly to bless your doings through the day. Forget not the singing and the reading in the Bible.

Here the author suggests Bible reading and prayer and singing as a morning custom. What is a "custom"? (Something one does regularly.) What does he mean by "coldly"? (Unfeelingly.) What are your morning customs?

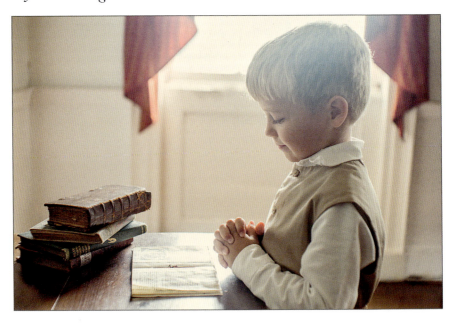

Discussion Guide

11. Do not eat your morning bread upon the road or in school, but ask your parents to give it to you at home.

Do you eat on the way to school? What do you think the author means by "your morning bread"? (Children in colonial days would often have simply milk and bread for breakfast—no toaster pastries or sugary boxed cereal!)

12. Then get your books together and come to school at the right time.

We can see that even in 1764 it was important to be at school on time!

B. *In the evenings at bed-time.*

13. After the evening meal do not sit down in a corner to sleep, but perform your evening devotions with singing, prayer and reading, before going to bed.

Children in the 1700s didn't have TV, recorded music or the Internet like we do today. What do you usually do after dinner? These children also didn't have electricity or plastics. Think about how your life would be different if you didn't have anything electric or anything made with plastic.

Discussion Guide

14. Undress yourself in a private place, or if you must do it in the presence of others, be retiring and modest.

Homes in these days were often one single large room. The room might be divided with hanging curtains, or it might not! Privacy was more of a challenge in those days, and people needed to learn to give others privacy by looking away from them in their private moments. What does it mean to be "modest"? (To give regard to decency in your behavior; to keep oneself covered up as best as the situation allows.)

15. Look over your clothes to see whether they are torn, so that they may be mended in time.

What does it mean to "mend" clothing? Does your family mend your clothes?

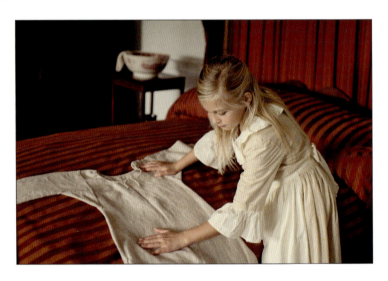

16. Do not throw your clothes about in the room, but lay them together in a certain place, so that in the morning early you can easily find them again.

What does this rule imply about how many different sets of clothing these children likely had?

Discussion Guide

17. Lie down straight in the bed modestly, and cover yourself up well.

You can see that in the 1700s, children even needed to sleep modestly! (Many of them did not have "pajamas" like we do today; they simply slept in their undergarments.)

18. Before going to sleep consider how you have spent the day, thank God for His blessings, pray to Him for the forgiveness of your sins, and commend yourself to His merciful protection.

Here the author recommends an evening custom of reflection and prayer. Why is it important to "consider how you have spent the day"? What are your evening customs?

19. Should you wake in the night, think of God and His omnipresence, and entertain no idle thoughts.

Have you ever woken in the night and felt afraid? What do you do when you are afraid in the night?

C. At meal-time.

20. Before going to the table where there are strangers, Comb and wash yourself very carefully.

Does your family have different traditions for dinner when you have company?

21. During the grace do not let your hands hang toward the earth, or keep moving them about, but let them, with your eyes, be directed to God.

Discussion Guide

Can you demonstrate what the author says children should look like when they are praying?

22. During the prayer do not lean or stare about, but be devout and reverent before the majesty of God.

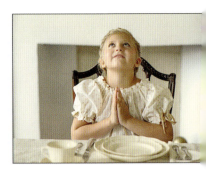

If your family prays before a meal, do you look around while it is happening?

23. After the prayer, wait until the others who are older have taken their places, and then sit down at the table quietly and modestly.

Why should children not sit down to eat before "those who are older"?

24. At the table sit very straight and still, do not wabble with your stool, and do not lay your arms on the table. Put your knife and fork upon the right and your bread on the left side.

Most meals in 1700s colonial America included bread. Why? (Bread was then—as now—a relatively inexpensive filler.)

25. Avoid everything which has the appearance of eager and ravenous hunger, such as to look at the victuals anxiously, to be the first in the dish, to tear off the bread all at once in noisy bites, to eat quickly and eagerly, to take another piece of bread before the last is swallowed down, to take too large bites, to take the spoon too full, to stuff the mouth too full, & etc.

Do your parents give you instructions on how to eat? How would you summarize this rule? Do you think polite eating is important?

26. Stay at your place in the dish, be satisfied with what is given to you, and do not seek to have of everything.

"Stay at your place in the dish" refers to the custom of sharing plates. Often, children in these days would share a single long "plate" with a sibling or two. So the author is saying not to sneak your spoon over to steal your little brother's food!

27. Do not look upon another's plate to see whether he has received something more than you, but eat what you have with thankfulness.

Do you ever compare what you get with what other members of your family receive at dinner? Do you think everyone should get exactly the same amount?

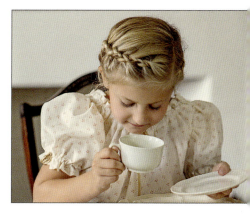

28. Do not eat more meat and butter than bread, do not bite the bread off with the teeth, cut regular pieces with the knife, but do not cut them off before the mouth.

Bread in colonial days was not pre-sliced like our bread usually is today. A family would often share an entire loaf of bread for dinner. The author is saying not to pick up the whole loaf and take a bite out of it! Do you think that's good advice?

29. Take hold of your knife and spoon in an orderly way and be careful that you do not soil your clothes or the table cloth.

Eating properly takes some thinking. The next time you are eating with your schoolmates or siblings, watch them to see if everyone is eating carefully.

Discussion Guide

30. Do not lick off your greasy fingers, wipe them on a cloth, but as much as possible use a fork instead of your fingers.

 This rule says that children should wipe their fingers on a cloth. In the 1700s, colonial Americans didn't have disposable paper products like napkins (and toilet paper). How would your life be different without disposable paper products?

31. Chew your food with closed lips and make no noise by scraping on the plate.

 Have you ever eaten a meal with someone who didn't close their lips when they were chewing? Or liked to scrape their fork on the plate?

32. Do not wipe the plate off either with the finger or the tongue, and do not thrust your tongue about out of your mouth. Do not lean your elbows on the table when you carry the spoon to the mouth.

 If you were sharing a plate with your little brother, you would certainly not want him licking the plate!

33. Do not take salt out of the salt-box with your fingers, but with the point of your knife.

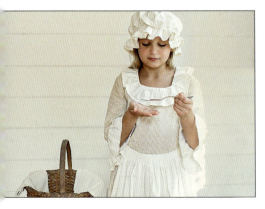

The families in this day didn't have saltshakers like we do today, so the salt was kept in a box. (Anti-caking agents weren't developed until the 1900s, which is why our modern saltshaker wouldn't have been the best choice for dispensing salt in colonial days.) Why does the author say to use a knife to get some salt?

Discussion Guide

34. The bones, or what remains over, do not throw under the table, do not put them on the table cloth, but let them lie on the edge of the plate.

Do you ever sneak food you don't want underneath the table? Or onto someone else's plate? Or to a pet?

35. Picking the teeth with the knife or fork does not look well and is injurious to the gums.

What do we use to clean between our teeth today? What food do you think gets stuck in between your teeth the most?

36. As much as possible abstain from blowing your nose at the table, but if necessity compels, turn your face away or hold your hand or napkin before it; also when you sneeze or cough.

What does abstain mean? (To keep from doing something.) This is still a good rule today, isn't it?

37. Learn not to be delicate and over-nice or to imagine that you cannot eat this or that thing. Many must learn to eat among strangers what they could not at home.

Do you know a child who refuses to eat new foods?

38. To look or smell at the dish holding the provisions too closely is not well. Should you find a hair or something of the kind in the food, put it quietly and unnoticed to one side so that others be not moved to disgust.

Have you ever found anything unpleasant in your food?

Discussion Guide

39. As often as you receive anything on your plate, give thanks with an inclination of the head.

 What does "inclination" mean? Why do you think the author said to incline one's head instead of saying "thank you"?

40. Do not gnaw the bones off with your teeth or make a noise in breaking out the marrow.

 What is the "marrow"? (The soft, fatty inside of a bone.) What does it mean to "gnaw"? (To nibble at something, usually meat on a bone.) Do you eat the marrow out of bones?

41. It is not well to put back on the dish what you have once had on your plate.

 Why is this a good rule?

DISCUSSION GUIDE

42. If you want something across the table be careful not to let your sleeve hang in the dish or to throw a glass over.

Has this ever happened to you?

43. At table do not speak before you are asked, but if you have noticed anything good at church or school, or a suitable thought occurs to you relating to the subject of discourse, you may properly bring it forward, but listen attentively to the good things said by others.

What is "discourse"? (Written or spoken communication.) Children were expected to be respectful in the presence of adults. One of the ways this respect was shown was by a child not speaking to an adult unless the adult has spoken to the child first. Do you think this is a good rule?

44. When you drink you must have no food in your mouth, and must incline forward courteously.

Why is it best to drink after you have swallowed your food?

45. It has a very bad look to take such strong draughts while drinking that one has to blow or breathe heavily; while drinking to let the eyes wander around upon others; to commence drinking at table before parents or more important persons have drunk; to raise the glass to the mouth at the same time with one of more importance; to drink while others are speaking to us; and to raise the glass many times after one another.

Have you ever been around someone who, while drinking, was panting between slurps? Do you think the way you eat and drink can show respect—or disrespect—for others at the table?

Discussion Guide

46. Before and after drinking, the mouth ought to be wiped off, not with the hand, but with a handkerchief or napkin.

Apparently milk moustaches were a problem even in the 1700s!

47. At the table be ready to help others if there is something to be brought into the room or other thing to be done that you can do.

What responsibilities do you have in regard to dinner preparations?

48. When you have had enough, get up quietly, take your stool with you, wish a pleasant meal-time, and go to one side and wait what will be commanded you. Still should one in this respect follow what is customary.

Why do you think the author says to "take your stool with you"? (The children likely had a single seat that was "theirs," and if they wanted to sit down on it, they had to carry it around.)

49. Do not stick the remaining bread in your pocket but let it lie on the table.

Have you ever stuck bread in your pocket?

50. After leaving the table, before you do anything else, give thanks to your Creator who has fed and satisfied you.

Do you thank whoever cooks your meals? How about the people working in the cafeteria at your school?

Discussion Guide

II. Rules for the Behavior of a Child in School.

51. Dear child, when you come into school, incline reverently, sit down quietly in your place, and think of the presence of God.

What does "incline reverently" mean? Can you demonstrate how to do that?

52. During prayers think that you are speaking with God, and when the word of God is being read, think that God is speaking with you. Be also devout and reverential.

In this day, it was common in the colonies to teach from the Bible in school. In our day, public schools do not teach from a specific religious perspective. Do you think this is a good idea?

53. When you pray aloud, speak slowly and deliberately; and when you sing, do not try to drown the voices of others, or to have the first word.

Do you know anyone who tries to sing louder than everyone else?

54. Be at all times obedient to your teacher, and do not let him remind you many times of the same thing.

This is still a good rule today!

55. Should you be punished for bad behavior, do not, either by words or gestures, show yourself impatient or obstinate, but receive it for your improvement.

School punishment in the 1700s (and, in fact, in the 1800s and 1900s) occasionally included causing the student to be made "physically

Discussion Guide

uncomfortable." The teacher, usually with a paddle or "switch," would strike the student, typically on the buttocks. How do you think school would be different if we still did that today?

56. Abstain in school from useless talking, by which you make the work of the schoolmaster harder, vex your fellow pupils, and prevent yourself and others from paying attention.

What does it mean to "vex your fellow pupils"? How does "useless talking" disturb the classroom?

57. Listen to all that is said to you, sit very straight and look at your teacher.

Why is it good to sit straight up in school?

58. When you recite your lesson, turn up your book without noise, read loudly, carefully and slowly, so that every word and syllable may be understood.

Why is it important to read "loudly, carefully and slowly"?

59. Give more attention to yourself than to others, unless you are placed as a monitor over them.

In our day, we often abbreviate this rule as "M.Y.O.B." What does that stand for? Why is it a good idea to "mind your own business"? Is it ever NOT a good idea to "mind your own business"?

60. If you are not questioned, be still; and do not help others when they say their lessons, but let them speak and answer for themselves.

Why should a student "be still" when another student is called upon? Why is it best to let others speak for themselves?

61. To your fellow-scholars show yourself kind and peaceable, do not quarrel with them, do not kick them, do not soil their clothes with your shoes or with ink, give them no nick-names, and behave yourself in every respect toward them as you would that they should behave toward you.

Who are your "fellow-scholars"? Why does the author say to not "soil their clothes…with ink"? Why did he bring that up? (Students would often use quill pens, which drew ink from a small glass container on their desks—unlike the pens we have today, in which the ink is usually held in place by a metal ball. This ink, as one may imagine, could get one quite messy if used improperly.)

62. Abstain from all coarse, indecent habits or gestures in school, such as to stretch with the hands or the whole body from laziness; to eat fruit or other things in school; to lay your hand or arm upon your neighbor's shoulder, or under your head, or to lean your head forwards upon the table; to put your feet on the bench, or let them dangle or scrape; or to cross your legs over one another, or stretch them apart, or to spread them too wide in sitting or standing; to scratch your head; to play or pick with the fingers; to twist and turn the head forwards, backwards and sideways; to sit and sleep; to creep under the table or bench; to turn your back to your teacher; to change your clothes in school, and to show yourself restless in school.

If you could summarize all these specific rules into one general rule, what would it be? Is there anything else you think should be included in this list?

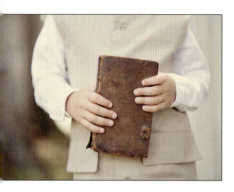

63. Keep your books, inside and outside, very clean and neat, do not write or paint in them, do not tear them, and lose none of them.

Books in these days were normally hard-covered with a stitched binding, similar to many textbooks today. Schools did not contain thousands of books like our schools do today, and books were much more valuable and rare. It was very important to care for them so they would provide years of use. Do you think we should still treat books with care today?

64. When you write, do not soil your hands and face with ink, do not scatter it over the table or bench, or over your clothes or those of others.

Why was it more likely to "soil your hands and face with ink" in that day? (See #61)

65. When school is out, make no great noise; in going down stairs, do not jump over two or three steps at a time, by which you may be hurt, and go quietly home.

Do most of the students in your school "go quietly home"? Or perhaps "jump over two or three steps at a time"?

Discussion Guide

III. How a Child should Behave on the Street.

66. Dear child, although, after school, you are out of sight of your teacher, God is present in all places and you therefore have cause upon the street to be circumspect before Him and his Holy Angels.

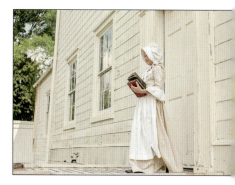

Is it important to "do the right thing" even when nobody else can see you?

67. Do not run wildly upon the street, do not shout, but go quietly and decently.

What does it mean to "go decently"? (To be respectable; to have moral, dignified behavior.)

68. Show yourself modest, and do not openly, before other people, what ought to be done in a private place.

We don't need to mention specifics—but there are things you should only do when you're alone!

69. To eat upon the street is unbecoming.

What does "unbecoming" mean? (Not appropriate; not respectable.)

70. Do not stare aloft with your eyes, do not run against people, do not tread purposely where the mud is thickest, or in the puddles.

What does it mean to "run against people"? Have your parents ever told you not to "tread purposely…in the puddles"?

Discussion Guide

71. When you see a horse or wagon coming, step to one side, and take care that you do not get hurt, and never hang behind upon a wagon.

This same rule applies today, except instead of a horse and wagon, we would say what?

72. In winter do not go upon the ice or throw snowballs at others, or ride upon sleds with disorderly boys.

It is not clear whether or not one may "ride upon sleds" with orderly boys!

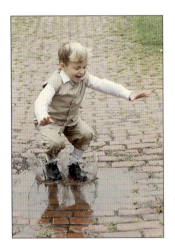

73. In summer do not bathe in the water or go too near it. Take no pleasure in mischievous or indecent games.

What does "mischievous" mean? (Having a fondness for trouble.) Many people in that day would take a bath indoors and not always get completely wet when bathing; they would just clean certain parts, such as the face. They didn't have showers like we do today.

74. Do not stand in the way where people quarrel or fight, or do other evil things; associate not with evil companions who lead you astray; do not run about at the annual fair; do not stand before mountebanks or look upon the wanton dance, since there you learn nothing but evil.

Entertainment options were limited for children in these days, so the annual fair was the cause of great excitement. The fairs would often have people who would try to sell items of questionable worth; these are the "mountebanks": salesmen trying to sell a product that may or may not do what they were claiming. Have you ever seen anything at a fair you thought wasn't quite right?

75. Do not take hold of other children so as to occupy the street, or lay your arm upon the shoulders of others.

The author here seems to be discouraging appearing as a "gang."

76. If any known or respectable person meets you, make way for him, bow courteously, do not wait until he is already near or opposite to you, but show to him this respect while you are still some steps from him.

Is this a good way to show respect to someone? Try this the next time you see an adult—stop walking before he or she passes you, and bow gently. See if it feels respectful!

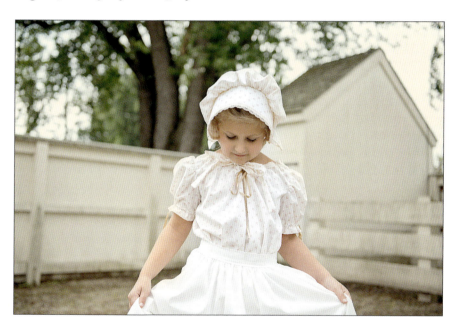

IV. Rules for the Behavior of a Child in Meeting or Church.

77. Dear child, in meeting or church think upon the holy presence of God, and that you will be judged according to the word you hear upon this day.

What does the author mean "you will be judged"? What is he talking about?

78. Bring your Bible and hymn book with you, and sing and pray very devoutly, since out of the mouths of young children will God be praised.

If you go to church or some kind of religious service, do you participate, or do you sit and think about other things?

79. During the sermon be attentive to all that is said, mark what is represented by the text, and how the discourse is divided; which also you can write on your slate. Refer to other beautiful passages in your Bible, but without noise or much turning of the leaves, and mark them by laying in long narrow bits of paper, of which you must always have some lying in your Bible.

What does the author mean when he says to "write on your slate"? (A small portable chalkboard.) What does he mean by "leaves"? (The thin pages of the Bible.)

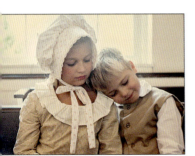

80. Do not talk in church, and if others want to talk with you do not answer. During the sermon, if you are overcome with sleep, stand up a little while and try to keep it off.

If you go to church or some kind of religious service, do you ever fall asleep there? Have you seen someone else fall asleep?

Discussion Guide

81. When the name of Jesus is mentioned or used in prayer uncover or incline your head, and show yourself devout.

Here again the author mentions bowing or lowering the head as a way of showing respect.

82. Do not stare about the church at other people, and keep your eyes under good discipline and control.

Do you ever find it hard to control your eyes? Do you think this is important?

83. All indecent habits which, under Rule No. 62, you ought to avoid in school, much more ought you to avoid in church.

Why do you think many people behave differently when they are with a pastor or a priest?

84. If you, with others, should go in couples into, or out of, the church you should never, from mischief, shove, tease or bespatter, but go forth decently and quietly.

What do you suppose "bespatter" means? (To splatter with drops of some kind of liquid.)

V. Rules for the Behavior of a Child under Various Circumstances.

85. Dear child, live in peace and unity with every one, and be entirely courteous from humility and true love of your neighbor.

What does it mean to "love your neighbor"?

86. Accustom yourself to be orderly in everything, lay your books and other things in a certain place and do not let them lie scattered about in a disorderly way.

Is this a rule you follow?

87. When your parents send you on an errand, mark well the purpose for which you are sent, so that you make no mistake. When you have performed your task come quickly home again and give an answer.

Do your parents ever have you run an errand? What kinds of errands do you go on?

88. Be never idle, but either go to assist your parents, or repeat your lessons, and learn by heart what was given you. But take care that you do not read in indecent or trifling books, or pervert the time, for which you must give an account to God, with cards or dice.

What does the author suggest a child should do when he or she is bored? What kinds of things do you normally do when you have "idle time"?

89. If you get any money, give it to some one to keep for you, so that you do not lose it, or spend it for dainties. From what you have, willingly give alms.

What is a "dainty"? (Something sweet and tasty to eat.) What does it mean to "give alms"? (Donate money to a church.)

90. If anything is presented to you, take it with the right hand and give thanks courteously.

Do your parents ever have to remind you to say "thank you"?

Discussion Guide

91. Should you happen to be where some one has left money or other things lying on the table, do not go too near or remain alone in the room.

Why is this a good rule?

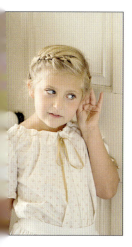

92. Never listen at the door, Sirach 21, 24. Do not run in quickly, but knock modestly, wait until you are called, incline as you walk in, and do not slam the door.

(Sirach is an ancient book of wisdom writing, similar to the book of Proverbs in the Bible.) Why should children never "listen at the door"?

93. Do not distort your face, in the presence of people, with frowns or sour looks; be not sulky if you are asked any thing, let the question be finished without your interrupting, and do not answer with nodding or shaking the head, but with distinct and modest words.

It is possible to do what your parents or teachers tell you to do, but to do it in such a way that it communicates disrespect or defiance. Do you think it's important to show respect with your attitude as well as your behavior? What does it mean to be "sulky"?
(To have a sad, grumpy attitude.)

94. Make your reverence at all times deeply and lowly with raised face. Do not thrust your feet too far out behind. Do not turn your back to people, but your face.

Do you feel it is rude to "turn your back" to people?

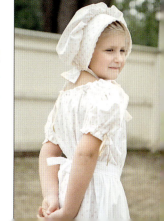

Discussion Guide

95. Whether a stranger or good friend comes to the house, be courteous to him, bid him welcome, offer him a chair and wait upon him.

Do you follow this rule at home?

96. In sneezing, blowing the nose, spitting, and yawning be careful to use all possible decency. Turn your face to one side, hold the hand before it, put the uncleanliness of the nose in a handkerchief and do not look at it long, let the spittal fall upon the earth and tread upon it with your foot. Do not accustom yourself to continual hawking, grubbing at the nose, violent panting, and other disagreeable and indecent ways.

Remember this the next time you blow your nose in school! How would you summarize this rule?

97. Never go about nasty and dirty. Cut your nails at the right time and keep your clothes, shoes and stockings, neat and clean.

What does the author mean by "stockings"? Why is it important to not "go about nasty and dirty"?

98. In laughing, be moderate and modest. Do not laugh at everything, and especially at the evil or misfortune of other people.

What does it mean to "laugh...at the misfortune of other people"? What is an example of a misfortune that some may find funny?

99. If you have promised anything try to hold to it, and keep yourself from all lies and untruths.

Have you ever broken a promise? Has anyone ever broken a promise to you?

100. Let what you see of good and decent in other Christian people serve as an example for yourself. "If there be any virtue, and if there be any praise, think on these things." Philippians iv, 8.

Who is your hero or role model?

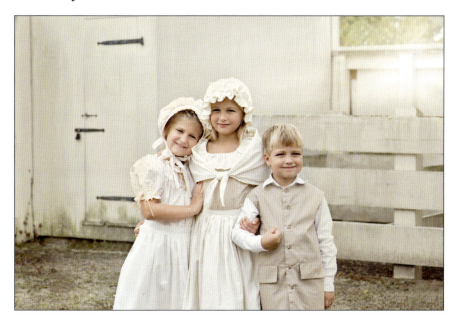

After Reading Activities

For Teachers and Homeschooling Parents

When sharing in a classroom, keep in mind the text of the "Rules" (not the photographs or the Discussion Guide) are in the public domain and may be copied and distributed to students.

After the rules have been shared with your child or students, you can choose from some of the following activities.

ART: Have students choose one or several rules to illustrate to hang in the classroom—first the text and then a picture that illustrates the rule. The rules can be chosen by lot, or the student may simply choose one or several rules.

DRAMA: Dramatic interpretations of the rules are lively and get the students moving. Students can be assigned (or choose) several rules to demonstrate. Some simple props (plates, a table, a desk, etc.) can be prepared, or the students can pantomime. One student in a group states the rule while the others act it out. (For fun, you can also allow students to demonstrate someone *not* following the rule, but be careful with that one!) If laptops with webcams (or video cameras) are available, students can record their rules to create a video to show to the class, or if technology is not available or desired, the rules can be performed live as skits.

After Reading Activities

WRITING: 1) Assign students to write their own modern versions of the rules for children. Students are to use the same five categories as in the original version and should include two to three rules per section. The rules should have the same tone as the original: "To text upon your cellphone whilst at the dinner table is unbecoming."

2) Students use the rules as a textual reference for an essay: "Compare and contrast the lives of children in Mr. Dock's school with students today." The report should include observations about the meaning of the rules and what they imply about colonial life and how the lives of the children in colonial days compare to the lives of modern students.

Visit us at
www.historypress.net

This title is also available as an e-book